The British Library

COLIN ST JOHN WILSON ART SPACES

INTRODUCTION

There are certain types of building over which there hovers an aura of myth. The most transcendent of all, the cathedral, is grounded in the sacred so that both form and pattern of use are fused in the language of ritual. But there is one type of building which is profane, yet in fulfilling its proper role touches the hem of the sacred: the great library. One has only to recall the destruction of the library in Alexandria or, akin to that fire, the blasphemy that underlay the burning of the books by Nazi decree, for one to be made aware that the library and what it houses embody and protect the freedom and diversity of the human spirit in a way that borders on the sacred. And so, as someone brought up in a den of books in a family one half of which were publishers and writers, for me the idea of building a great library was always (next to a cathedral!) the most haunting of ambitions.

As you enter the British Library you are drawn into a concourse whose ceiling gently rises in curving vaults like waves, pouring light down in a procession that leads

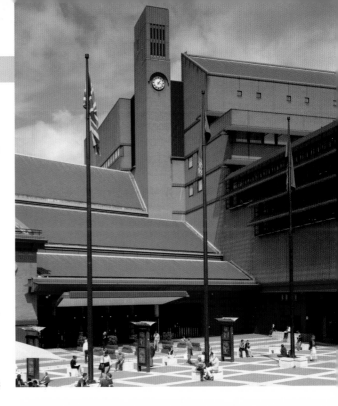

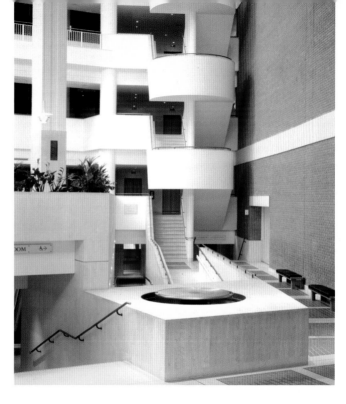

← The front of the British Library at St Pancras. Above the entrance doors, the three 'steepening waves' of the concourse roof lead up to the Library's distinctive clock tower.

→ The Main Entrance Hall (viewed here from the entrance) draws the brick walls of the piazza inside to meet the white plaster of the Reading Rooms.

towards a tower of books, six floors high, framed in bronze and glass and gently glowing with the colour of leather and vellum bound books whose spines add a further glitter of red and gold and black titles. It is the collection of books put together by George III and donated to the nation by George IV who, in the terms of his gift, insisted that they be placed on exhibition to the public. And so there they stand in all their glory.

But in this they are unique within the Library because all the rest of the collections are buried out of sight of the public in huge basements four floors deep. Nevertheless the tower stands there as a beacon or symbol of their presence. What the collections embrace is almost unparalleled in the scale and range of its subject matter, covering 400 different languages, amounting to over 150 million items of rare books,

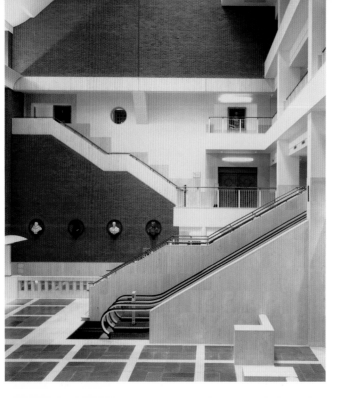

← The Main Entrance Hall of the Library, viewed from the East Staircase. On the far wall, beyond the escalators, can be seen four roundels holding the busts of major donors to the collections.

manuscripts, maps and musical scores, and growing each year by 12½ kilometres of additional shelving.

The birth of the whole project was difficult, and a hard time we had of it: we made full designs for three projects on two completely different sites over a period of 36 years. It coincided with the dawn of 'The Information Age' and was attended by two rival factions. On the one hand there were the steely-eyed 'men of the future', prophesying the death of the book and denouncing the project as a white elephant. On the other hand establishment academia, deeply and understandably attached to the Round Reading Room of the British Museum, became locked in nostalgic denial of its incapacity to meet the huge expectation of demands upon it.

↓ The six-storey bronze and glass tower of the King's Library, which features mobile shelving, internal lifts and a stairwell, to ensure that books can be retrieved by staff from all parts of the stack. The bust of George III is by Turnerelli (1812).

→ The corner of the freestanding tower of the King's Library.

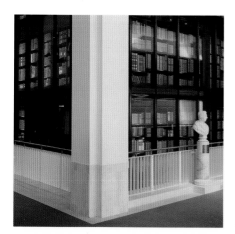

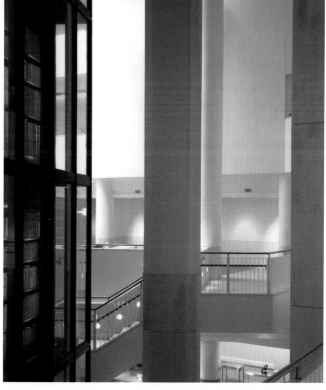

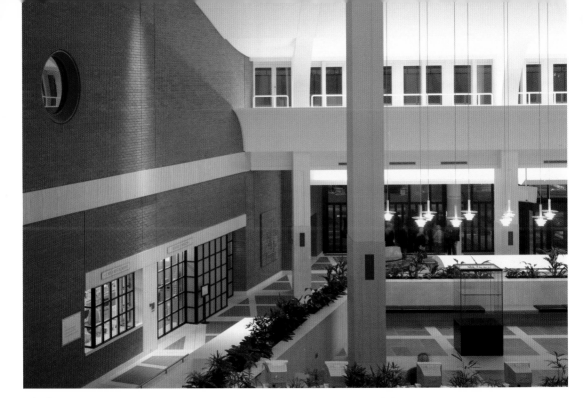

← The main concourse, looking back towards the entrance, with the east wall on the left.

→ The entrance hall viewed from the circular window in the east wall. Left of centre is a tapestry by the Edinburgh Weavers based on R. B. Kitaj's painting *If not, not*.

In the event, the book (which many of us believe to be the greatest invention since the wheel) has enjoyed an unprecedented resurgence and the annual rate of publication continues to spiral upwards. Even Homer has shifted a little to allow space for Harry Potter. New electronic means of information transmission have indeed developed on a huge scale but they have proved to be not rivals but parallel resources in amicable symbiosis. The Library's Entrance Hall is now abuzz with the activities of a new species of reader: the 'wandering scholar of the laptop', who shares the same interest in the tables of the café and restaurant as the sedate scholar of traditional discipline, and brings another dimension to the spirit of the place.

There was a further unpredicted shift in fortune. The decision in 1975 to move the project from Bloomsbury to

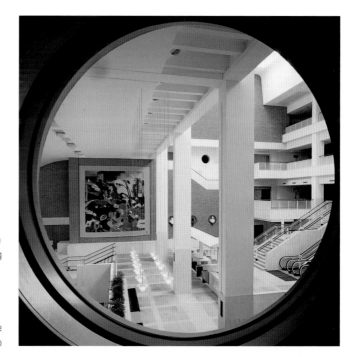

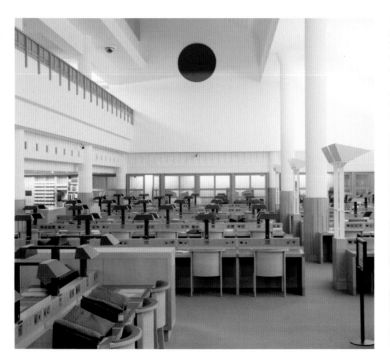

← Rare Books and Music, the first reading room to be entered from the west wall of the entrance hall.

→ The main reading area of the triple-height South Science Reading Room, the first to be entered through the east wall.

↓ Detail of bookshelves in the Humanities Reading Room.

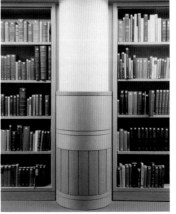

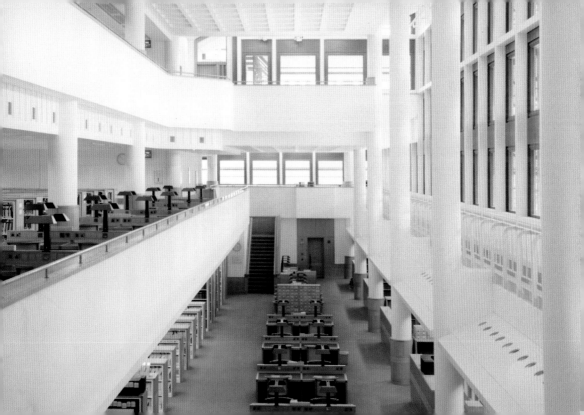

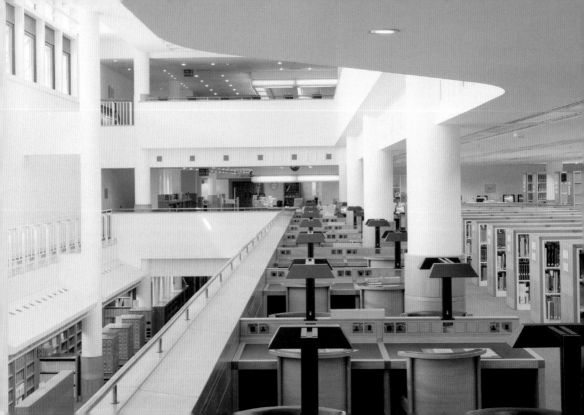

← Reverse view of the South Science Reading Room.

→ The British Library viewed through its principal entrance portico on Euston Road.

St Pancras was principally motivated by the need for more space, both initially and for subsequent expansion. The decision, many years later, to locate the Channel Tunnel Rail Link Terminal at St Pancras has totally transformed accessibility to the Library, both nationally and internationally. The piazza will surely become the most convenient place of welcome and farewell to visitors worldwide. Soon, maybe, boy from London will meet girl from Paris under the clock, even as visiting scholars gather to participate in conferences and seminars in the busy Conference Centre. The need to house and make accessible the treasures that are unique is changeless. But change will unfold relentlessly; and since the design policy of the building was based upon a calculated balance of fixed and flexible characteristics, the great challenge in the future will lie in the ability to adapt to change that it has successfully pursued since the doors were opened for the first time in 1998.

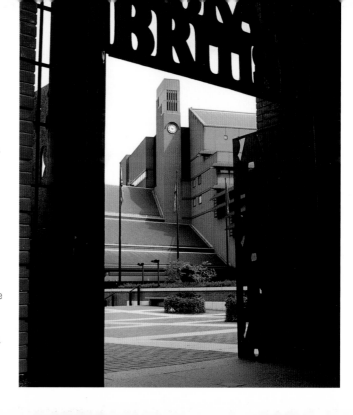

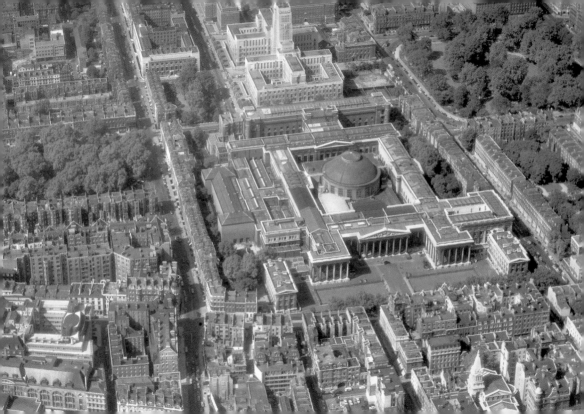

I. THE HISTORICAL BACKGROUND

← Aerial view of the Bloomsbury district of London in August 1959, looking north, with the British Museum at the centre. The dome in the museum's central courtyard (now the Great Court) houses the round Reading Room, home of the British Library until 1998. The area south of the Museum's neo-classical frontage was the site of the first two designs for the new Library. Only Hawksmoor's church of St George's, Bloomsbury – its remarkable steeple can be seen at the bottom right of the page – would have survived the demolition required by these original schemes.

'This job may take some time,' muttered the Chairman of the Selection Committee that appointed Sir Leslie Martin and me to design the new Library for the British Museum in 1962. He was a gentleman who looked like Sydney Greenstreet in *The Maltese Falcon*, and a hooded but steely eye seemed to be calculating the odds on my chances of attaining the necessary longevity. His findings appeared to reassure him.

The Trustees of the British Museum had set out to pursue the proposal put forward in the 1951 County of London plan to relocate the Museum's Library and Department of Prints and Drawings to land south of the Museum, between Great Russell Street and Bloomsbury Way. By that time the Museum's Library had overgrown the famous Round Reading Room of 1857, the book stacks in the Great Court were full up, and far too many books had to be housed off site.

The Museum brief was expanded to embrace a mixed development of residential, commercial and office use to compensate for the property to be demolished;

and a design was completed by mid-1964 and approved by the Government of the day that autumn. Its principal feature, made possible by the projected closure of Great Russell Street, was a broad plaza connecting the Museum directly to the new development and the eighteenth-century church of St George's, Bloomsbury, designed by Nicholas Hawksmoor.

The Eastern half of the site was allocated to the Library building. This was dominated by a three-floor-high terraced Reading Room, flanked on two sides (west and east) by the six Humanities Department Reading Rooms (Maps, Manuscripts, State Papers, Periodicals, Oriental and Music Collections). Lying in the L-shape interspace between the base of the major Reading Room and the six Departmental Reading Rooms was the Catalogue Hall, over which the stepped terraces of the Reading Room loomed like a ship in dry dock.

The major part of the collections were to be stored in seven floors (four of which were below ground) under the Reading Rooms in a deep space whose external

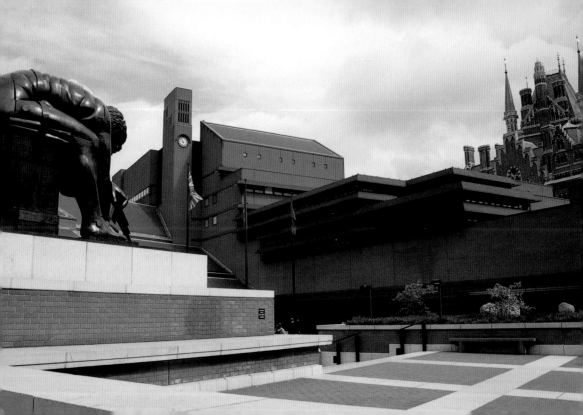

perimeter above ground housed the offices of the various Departmental Collections.

To the west would stand St George's church, now freestanding for the first time in its history, and beyond it the Department of Prints and Drawings. The rest of the land to the west was allocated to a residential development for 350 people, distributed in terraced form around a central green space, with 3,000m^2 of commercial space and 2,000m^2 of office accommodation tucked in around the perimeter, together with a couple of public houses.

The design had a certain grand simplicity, square in plan and symmetrical about the northwest/southeast diagonal, but it would have had to be constructed all at once and would have afforded little opportunity to take on board any changes in requirements, and none to follow for growth.

In 1966 (ratified by Act of Parliament in 1973), a momentous shift in policy led to the birth of the British Library as an institution separate from the British Museum. This entailed bringing to the site the outhoused Science and Patents Collections, which effectively doubled the accommodation required to be

housed there. At the same time the site area had been reduced in size by the decision to preserve the whole of the west side of Bloomsbury Square; and the planning authority would not concede a *pro rata* reduction in the amount of residential development to be provided on the residue of the site.

At this time Sir Leslie Martin withdrew from the project and I was asked to prepare a new design to meet the radical shift in circumstances. Predictably, the design that emerged was massively overcrowded, and this, together with the increasing strength of the 'Save Bloomsbury' campaign, led to the decision in 1973 to look for an alternative site. The one chosen was in Somerstown St Pancras, on nine of the twelve acres to be vacated by British Rail.

Intensive exploration of alternative strategies led to a new design that was attended with much goodwill. The Royal Fine Art Commission applauded it as 'a brilliant solution to a very complex problem' and it was formally approved by the then Secretary of State for Education, Shirley Williams, in 1978.

The relocation of the site to St Pancras has proved to be enormously to the advantage of the Library, for a

← View of the British Library at St Pancras, facing towards the Sciences Wing, the Conference Centre and St Pancras Chambers, with Paolozzi's sculpture *Newton* at left in the foreground.

number of reasons. Firstly, the Bloomsbury site was never going to be large enough to allow for growth and change in the future. That inevitable contingency was one of the essential grounds for choosing the St Pancras site where the necessary additional land was indeed purchased to allow for growth after a first phase of construction. Furthermore, the unconstricted nature of the site made possible the deconstruction of the very large building mass into viable phases and sub-stages, which, it transpired, offered the only feasible strategy for dealing with the ensuing 'stop-go' Government funding of the project.

Secondly, the location on the Euston Road brought the Library into close proximity with three mainline railway terminals (Euston, St Pancras and King's Cross), thereby providing convenient connections to centres of learning outside London. Thirdly, the status of the area, which was judged by some to be sadly lacking in comparison with the neighbourly amenities found in Bloomsbury, was transformed by the proposal to site the Channel Tunnel Rail Link terminal at St Pancras. The Library will be the first building to greet the visitor, and the forecourt, which is the only large public space in the vicinity, will become the threshold to and from Europe, over and above its role as a place of relaxation for visitors to the Library.

When the doors were at last opened to the public in 1998, 36 years after the inception of the project in 1962, the approbation of both readers and staff was virtually universal, as witnessed by entries in the comments book and letters voluntarily submitted by visitors from all walks of life and age-groups; scholars by the score and members of the general public, ranging from a retired naval admiral to a girl 'seven years and three weeks old' who pronounced the Library 'BRILLIANT' and added, 'When I am older I hope I can work in the building.'

→ (left): Early architectural sketch for the St Pancras design. Irregular elements on left (west) linked by bridges over central concourse to orthogonal spine on right (east).

→ (right): Aerial view of the British Library at St Pancras, looking north-east. On the lower left edge can be seen Levita House. To the right, on Euston Road, which runs from the bottom to the right edge, is St Pancras Chambers. Behind is the span of St Pancras station concourse, subsequently extended northwards as the new Channel Tunnel Rail Link terminus. At top right is King's Cross station.

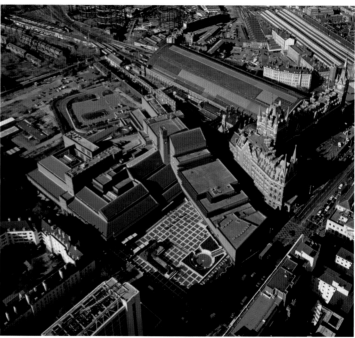

II. DESIGN PRIORITIES

The Organic Tradition

In designing the British Library building we have drawn widely upon the tradition of the English Free School, promoted by William Morris and John Ruskin, in which inspiration from Gothic architecture led to the concept of 'organic architecture', so cogently evoked by Ruskin himself (in his *Stones of Venice*) as:

> the only rational architecture… that which can fit itself most easily to all services, vulgar or noble. It can shrink into a turret, expand into a hall, coil into a staircase or spring into a spire, with undegraded grace and unexhausted energy… it is one of the virtues of the Gothic builders that they never suffered ideas of outside symmetries and consistencies to interfere with the real use of what they did.

This is demonstrated not only in the adoption of organic forms that are responsive to growth and change, but also in the repertoire of sensuous materials that are particularly responsive to human presence and touch: leather, marble, wood and bronze. We touch, hear and smell a building as much as we see it, and furthermore, what we do see in terms of weight and texture, density or transparency, transmits explicit resonances of a body

↓ Natural materials, responsive to touch and easy to maintain, are chosen. Here we find Portland stone stairs with brass and leather-clad handrails.

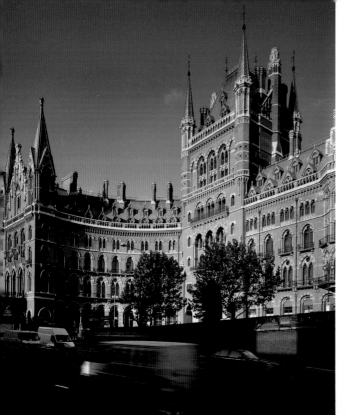

← Sir George Gilbert Scott's
St Pancras Chambers (known as
the Midland Grand Hotel until
1935), a remarkable example of
the English Free School.

language that is common to us all, but all too seldom
consciously addressed.

The English Free School is a tradition that, unlike
the hardline modernist obsession with 'progress', never
sought to cut itself off from the past nor deny itself
allusion to precedent, and always retained a blood
relationship with painting, sculpture and handicrafts
in an age increasingly committed to mechanical
reproduction; and the fact that the principal building
neighbouring the British Library, St Pancras Chambers,
is a spectacular example of the English Free School,
was a coincidence to be relished.

The guiding principle in working within this tradition
is the conviction that the inspiration for design must
spring not, as is so often the case, from the imposition
of preconceived forms and ideas, but from a grasp of
purpose. The art of architecture lies in raising functional

order to the level of celebration, necessity to the level of enjoyment – in that order.

It is by eliciting in this way the essential and different patterns of use of the various parts of the building that each is given its own form, character and therefore identity. The sheer size of the building is broken down to the scale of its working operations and therefore to the scale of the visitors and staff using the building.

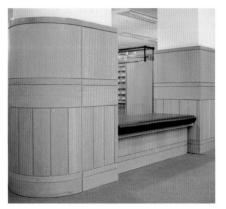

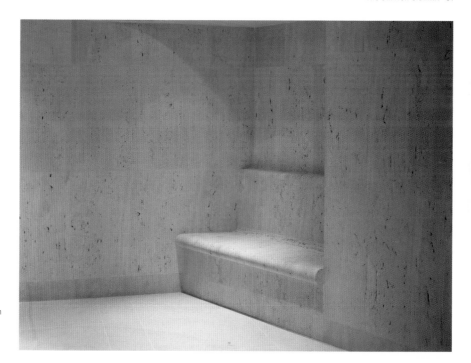

←→ Organic materials used in
public seating areas: leather,
wood panelling and carved
travertine marble.

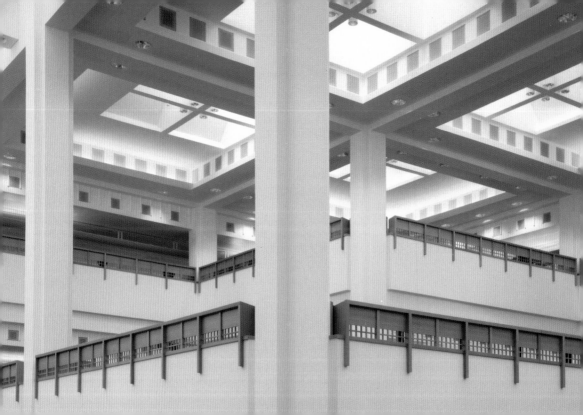

Natural Light

We made a primary decision that, wherever possible, the ambient light condition should be drawn from natural light. We had to fight hard for this because the 'expert' wisdom of the day strongly advocated the adoption of artificial light and environment in the interest of having universal 'flexible space' within which any function could be located anywhere. We held fast to the belief that all-day (sedentary) study required the stimulation and refreshment of ever-changing natural light. We also held that 'flexible space' was featureless and therefore soporific and that, on the contrary, a place of long stay should enjoy a positive identity and character.

The vertical organisation of the building was determined by this overriding importance that we attached to natural daylight. Thus the Reading Rooms are located at the top under roof lanterns for natural daylight; the main areas where natural light has to be excluded (such as the Exhibition Galleries) at ground level; the mechanical plant for environmental services at first basement level; and the rest of the basements are dedicated to storage.

← Daylight floods into the Humanities Reading Room through roof lanterns.

→ The 'hanging garden' terraces offer a wide variety in the choice of workplace for each reader.

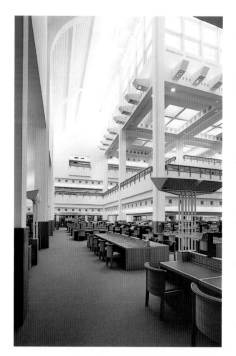

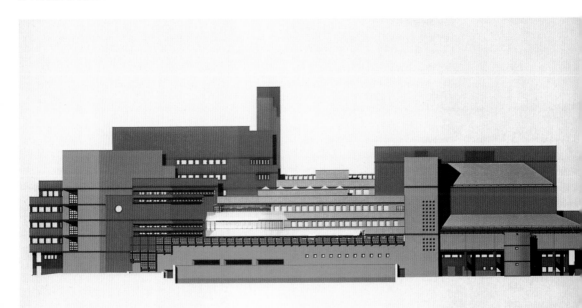

Growth and Change

Another overriding consideration grew out of the sheer size of the building as it emerged (200,000m²): it would be necessary to build the Library in phases as money became available. Accordingly, a design for a scheme to be executed in three main phases was prepared, and it had to be assumed that the need for growth over time would also have to embrace the possibility of change.

This inevitably had a determining effect on the Library's form, which establishes a core building containing a basic minimum of each type of accommodation at the southern (Euston Road) end of the site, and allows for a balanced expansion northwards of each type of readership.

Each stage was to be separated by vertical 'cores' providing lifts, stairs, and mechanical, electrical and book-handling services to each phase, acting furthermore as defining 'bookends' to provide a buffer for any one completed and self-sufficient phase during the construction of the next.

In the event, Phase I of the original three-phase scheme was itself broken down into three sub-stages of construction over a period of fourteen years. At least,

that was what we had intended in principle. In practice, however, neither architect nor Library ever knew whether the Government funding for the next stage would be forthcoming. The threat of 'no more money', together with the need to be self-sufficient at any time, put to the test the capacity for adaptation in a very severe way and also meant that the Library planners had to constantly revise priorities for the allocation of space onsite.

To cap it all, in 1992 the Government of the day forbade further implementation of the project and ordered the selling-off of the land originally acquired for purposes of expansion. Accordingly what was built by the time the Library was opened by the Queen in 1998 was Phase I only of the original three-phase scheme.

However, at the time of writing an extension to the north, in the form of a Conservation Centre, has been authorised by a new Government and is under construction, carried out by my former partners in the design of the Library, Long and Kentish, in association with me. It takes the form of a three-storey structure, extending north over the service yard to form a courtyard that is enclosed on its west and north sides by studio-

← Architect's silkscreen print of the north elevation.

workshops served by natural light from roof level. Further conservation facilities occupy the middle floor, and the ground floor is dedicated to the National Sound Archive. One of the great gains afforded by the design solution for this accommodation is the new courtyard, which will extend the narrative of the building to a whole new range of public outdoor activities.

Symbolic Form

There is a sense in which a library – especially the British Library, which is after all 'the Hall of Memory' – has to be celebrated over and above the observance of duty: there is an inherent symbolic content that has to be given its embodiment. At a time when there is no universally accepted architectural language in which to honour such abstract ideas, this is a delicate matter. Rhetoric, if it is to be intelligible, requires a public realm of shared values and beliefs. In writing about the absence of any such public realm in his time, the poet W. H. Auden wryly observed, 'Whenever a modern poet raises his voice he sounds phoney.' Today this search for an authentic language has become explosive at a time when there is little restraint on technical means.

← The East Staircase in the Main Entrance Hall. The circular column acts as the pivot for the change of axis in the grid.

→ The King's Library viewed from the belvedere tower. The spines of the leather and vellum bindings are brought to the face of the tower; the bookcases are mobile to permit staff to access books on request.

What is important for any such celebration, if it is to be free from phoney rhetoric, is that it should be grounded in the facts of the case – once again Ruskin's 'real use'. In the British Library the symbolic role is most truly embodied in the King's Library, a collection of 65,000 books, the majority of which were acquired by King George III. It was donated to the nation by his son, George IV, who ordained that its beautiful leather and vellum bindings be on show to the general public and not just to the scholars. The collection had hitherto been distributed in the wall-cases of the British Museum where its identity, however handsome, had the passive character of wallpaper decoration to the walls of a space otherwise dedicated to exhibitions. In the new building, the collection is housed in a free-standing structure, an object in its own right, a six-storey-high bronze and glass tower. By this transformation it becomes simultaneously a celebration of beautifully bound books, a towering gesture that announces the invisible presence of the other treasures housed below ground, and a hard-working source of material studied in the Rare Book Reading Room opposite. Its symbolic role lies not in a conventional decorative symbol but rather in the active celebration of its daily use.

It recalls, quite rightly, the building type used traditionally as a shrine, and there is even a certain analogy here to the famous Kaaba or 'Black Box' in Mecca.

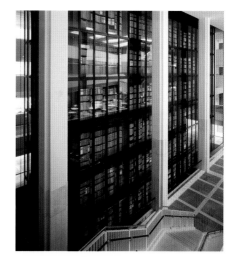

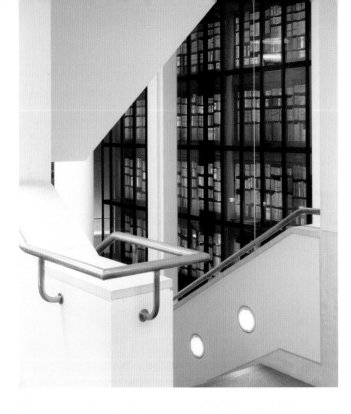

The occupancy of the greater part of the building is dedicated to purposes and practices of an unchanging nature. Technical innovation in the transmission of information will continue to modify the means of access to much of the material in the Library, but essentially most of the incomparable holdings in the historic collections will require storage and consultation in their original form. To consult the *Lindisfarne Gospels* or the manuscript of *Beowulf* the same basic conditions are required as those that were enjoyed when the work was first made.

It is a fundamental characteristic of modern art (most eloquently exemplified in the work of Eliot, Picasso and Stravinsky) that new meanings are evoked by the weaving together of allusion to precedent and innovation: and this building guards a number of allusions to new and old, to China, fifth century Rome, medieval Italy and the English Free School as much as to the works of Le Corbusier, Alvar Aalto and Louis Kahn of our own day.

← The King's Library glimpsed from the north-west staircase.

→ View past the west side of the King's Library, which contains 65,000 books donated to the nation by George IV.

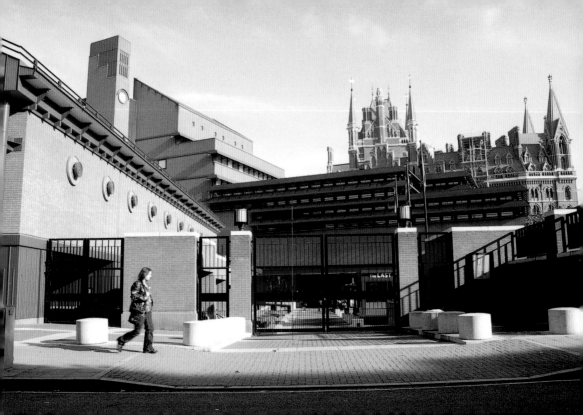

III. ELEMENTS OF THE BUILDING

The Site

The location of the British Library, sited on the Euston Road between Euston station to the west and St Pancras and King's Cross stations to the east, could not be bettered in terms of accessibility. The significance of the site will be enormously enhanced by the enlargement of St Pancras station to incorporate the main terminal of the Channel Tunnel Rail Link, which opens in 2007. The Library's existing linkage to the Underground network and thereby to the other mainline railway stations in London will be crowned by this transformation to international status.

There should be wide-ranging developments in the surrounding locality in response to the presence of both the Library itself and the Channel terminal; booksellers, publishers and the international community of scholars, as well as tourists, will together surely stimulate the flourishing of a new ambience of unique character, as the British Museum did in Bloomsbury. A whole new sector of London life is about to be generated.

← View of the Library looking east from outside Levita House, through the Ossulston Street gates into the piazza. Restricting the building height preserved views of St Pancras Chambers – seen here beyond the eastern flank of the Library, which contains the Science Reading Rooms and Conference Centre.

→ Site plan.

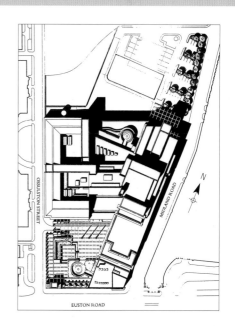

The Library lies between two neighbouring buildings of architectural consequence. To the west the remarkable residential building, Levita House, was constructed in 1926–29 following a visit of the Building Committee of the Borough of St Pancras to the famous 'workers' fortresses' in Vienna, of which the Karl Marx Hof by Karl Ehn is the most famous. Gentler by far than these imposing progenitors, and sadly disrupted in its original continuity of form by bomb-damage (would that it could be restored!), it still has a certain grandeur. With its courtyards and boldly arched pedestrian walkways, it presents convenient points of linkage, free from the traffic of Euston Road, to Chalton Street.

To the east stands St Pancras Chambers, one of London's great 'rogue' buildings, with its towers, sheer walls of brick and huge slate roof peppered with shafts of flues and dormer windows, built in 1867 by Sir George Gilbert Scott. There is a real sense in which, deeper than the borrowing of the Gothic idiom, there lies in this building a stirring of the organic form that was the birthmark of the English Free School, to which I have referred above as the tradition that underlies the design principle of the new Library. The equally great piece of

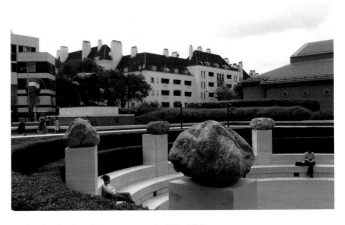

engineering for the railway concourse itself (by W. H. Barlow and R. M. Ordish) was, in its day, the widest clear-span of covered space in the world.

The southern (Euston Road) end of the site was bound to remain the principal approach by train, by tube and by bus, and of course on foot from the University of London and the British Museum. It was clear, however, that the bulk of the new building should be set back from

← Levita House looms in the background, beyond the western edge of the site. In the foreground is the small amphitheatre-like area of the piazza, known as Poet's Circle; mounted on plinths is Antony Gormley's sculptural piece *Planets*, consisting of eight one-tonne granite boulders carved with the outlines of human bodies in the act of emerging from them.

→ Paolozzi's *Newton*, the piazza and the Library, viewed from just inside the Euston Road portico. The section of the Library seen here houses the bookshop on ground level, and the Rare Book Reading Room and the Manuscripts Reading Room on upper levels.

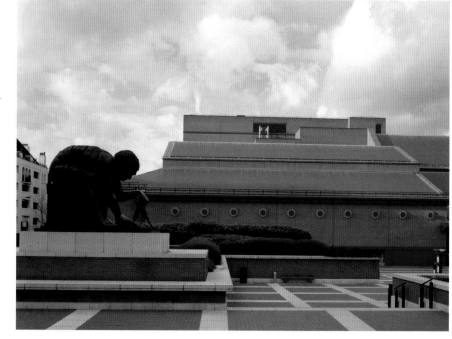

this frontage, principally in order to form an enclosed courtyard as protection from the hubbub of Euston Road, but also to preserve the stunning views of St Pancras Chambers when it is approached from the west along Euston Road.

Strict constraints upon building height were laid down by the planning authority; these limitations conspired to confirm the decision on grounds of environmental stability to locate the very large storage areas below ground.

The Piazza

The setting back of the building from Euston Road makes possible the creation of an enclosed courtyard, which mediates between the turmoil of traffic on the main road and the point of entry into the building. The piazza is further protected to the east from the heavy traffic on Midland Road by the projection of the Science Reading Room and Conference Centre southwards to Euston Road.

There are a number of entrances to the piazza, of which the principal one is through the portico sited in the southwest corner. A secondary entrance at the

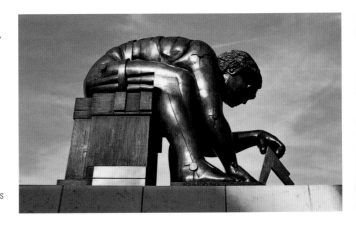

southeast corner passes diagonally under the Conference Centre from the point where, 'sotto-portico', it houses a small snack-bar. The axes of these two points of entry intersect at the location of a major sculptural monument: the bronze figure of Newton (after William Blake) by Sir Eduardo Paolozzi, a work that is monumental and yet, in the spirit of Blake, slyly irreverent in its depiction of a Michelangelesque giant

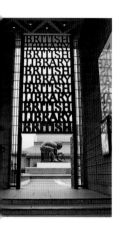

transmuting into a robot obsessed with measuring everything. Behind it and down the complete length of the western flank, an upper terrace offers the possibility of hosting such activities as second-hand book stalls, open-air celebrations or fairs. Steps and a ramp lead down to the main (lower) level of the piazza, in which a small amphitheatre, crowned by a ring of carved sculptures (ancient granite boulders transmuting into living bodies), forms the focus for other planned open-air events. A variety of places is thus provided for meetings or simply for private relaxation in good weather.

The Conference Centre has its own independent entrance in the piazza itself, but it can also be reached under cover by the third entrance point to the Library , which leads from Midland Road. The entrance from the piazza to the Library itself lies in the northeast corner of the courtyard, flanked to the left by the display window of the bookshop.

The general form of the building is a direct reflection of the volumetric content within and, as such, embodies the fundamental asymmetry in the patterns of use in the Reading Rooms (see pages 49–52). Thus the western range of the building houses the closed-access

← ↑ Paolozzi's *Newton*, viewed through the portico – with its bronze gates designed by the Cardozo Kindersley Workshop – and in close-up.

→ The eastern edge of the piazza, looking south towards Euston Road, past the entrance to the Conference Centre.

Humanities Reading Rooms and therefore has no windows, receiving its daylight through roof lights and clerestories; whereas the eastern range, which houses the open-access Reading Rooms of the Science Collections, derives its daylight from continuous side windows with horizontal louvres. The roof of the central entrance and concourse rises in a catenary of three steepening waves. The tower contains various service

shafts and serves also as a clock-tower.

The piazza is open in normal daytime hours to the general public: and since it is the only open public space in the neighbourhood and, furthermore, lies adjacent to the Channel Tunnel Terminal, it should become a place of rendezvous not only for the Library but also for visitors to London from near and far.

The big roof is both the most direct solution, as well as the clearest indication of the presence of large spatial volumes within. In so being, it not only helps to relate the Library to the roofs of St Pancras Chambers compositionally but also, by reference to many historic precedents, underlines the monumental status of the Library itself.

Brick was chosen as the facing material, both because it is the one material that in this climate improves rather than degenerates in appearance over time, and also to orchestrate the Library on a broad scale with St Pancras – the bricks for which came from the same source in Leicestershire. The colours for the metal sun louvres and the trim to the ground floor panels and columns were also selected as common to both buildings.

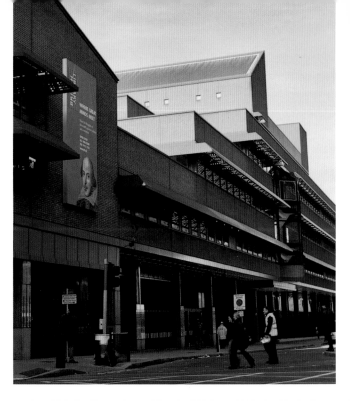

The Main Entrance Hall

The Main Entrance Hall to the Library takes the form of a generous concourse, affording not only access to the Reading Rooms for readers, but also for members of the general public to visit the Exhibition Galleries, the Bookshop and Centre for the Book, and school parties to visit the Education Service Department.

In large and complex buildings it is not easy to abide by the maxim 'one should not have to ask the way in a public building', but here the issue is resolved by the basic anatomy of the building that distributes the main components to either side of the central axial concourse. On entering, the visitor can instantly size up the general distribution of elements in the building and the route or point of entry to all the main destinations.

The architectural strategy has above all been to make the entrance a place of invitation, rather than a presence whose sheer size would seem to threaten the visitor. To this end the scale is modulated gently in progressive increments of size, starting with a ceiling that is low at the threshold but ascends in a sequence of waves to the full height at the centre, five and a half floors above entrance level.

← The Library's eastern façade on Midland Road. The roof continues to ascend to the left to form the 'prow' of the building that houses the slope of the auditorium.

→ The Main Entrance Hall, with the reception desk in the foreground. The canopies and suspended light fittings introduce into the tall space a datum at human body scale.

← The Humanities Reading Rooms on the west side are connected to the Sciences Reading Rooms on the east by three bridges, one of which is seen here at the top, that pass in front of the King's Library.

→ View of the Main Entrance Hall from the East Staircase; and architect's drawing, before construction, of a similar view ('the big wave').

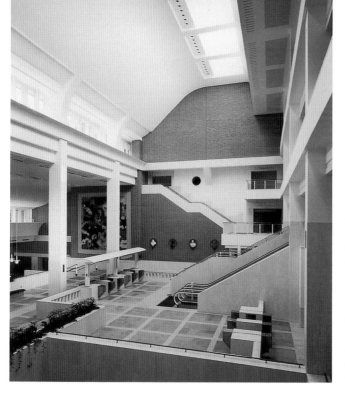

Secondly, the predominant light source is natural daylight, pouring in through clerestory and rooflights, reflecting off the light-coloured floor and permitting occasional shafts of sunlight to glance down the wall surfaces. As a result the passage of entry from the piazza is a gentle transition into an 'in-between' space, whose duality between inside and out is further underlined by the continuity into the interior of the wall and pavement finishes of the piazza.

Thirdly, the sheer size of the concourse is broken down to human scale by threading throughout the space elements of an intermediary scale. For example, the two bridges that connect the east and west ranges of

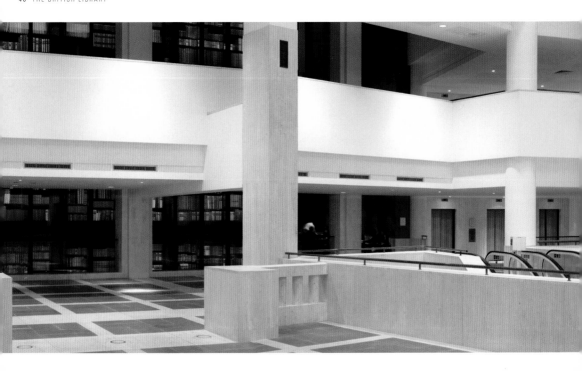

← Upper level of the main concourse, showing two bridges connecting the east and west ranges of the Reading Rooms, and the King's Library beyond.

→ The materials selected in the concourse are sensuous to touch: travertine marble sills and dados, and brass or leather-bound handrails.

Reading Rooms assert the 'normal' dimension of floor height. In the same way the canopies, carved seats and balustrades and the clusters of suspended lights assert a human scale, much as street-furniture (lamp-post, railing and pedestrian crossing) moderates and mediates between traffic and people.

Natural materials with self-finish not only reduce the level of maintenance but, above all, offer a sensuous response to touch: travertine, oak, leather, bronze and ebony.

The nature of the building as a Library is celebrated by the siting of a number of memorial busts and appropriate works of art. First the figure of Shakespeare by Roubiliac stands on a high plinth close to the entrance doors. Next the huge tapestry based on R. B. Kitaj's narrative painting *If not, not* hangs on the adjacent wall. It is a work which, as befits a library, makes a play with allusions both literary (Eliot's *Wasteland* and Conrad's *Heart of Darkness*) and pictorial (the *Tempesta* of Giorgione and a battlefield by Bassano). Beyond it four roundels carry the head and shoulder busts of major donors to the collections: Thomas Grenville by Nollekens, Sir Joseph Banks by

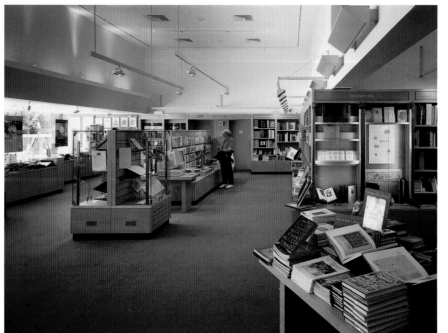

← View of the bookshop, reached direct from the Main Entrance Hall.

→ View of Entrance Hall, with Roubiliac's statue of Shakespeare on the left; the tapestry based on R. B. Kitaj's painting *If not, not* in the centre; and, beyond, the four roundels holding the busts of major donors to the Library.

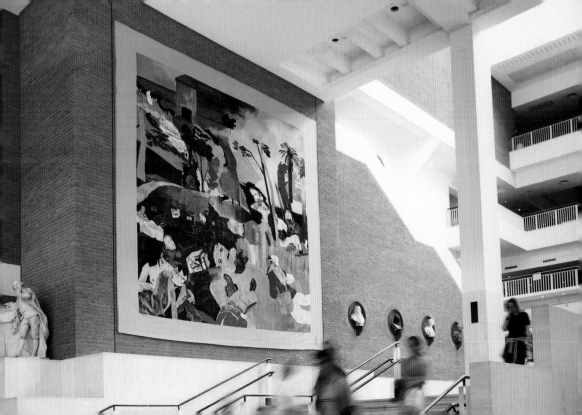

Damer, Sir Hans Sloane by Rysbrack, Sir Robert Cotton by Roubiliac.

In the ante-room to the Rare Books and Music Reading Room, herms carry the busts of Handel by Roubiliac, Vaughan Williams by David McFall (1957), Virginia Woolf by Stephen Tomlin and T. S. Eliot by Celia Scott (1997), and portrait paintings of Bach by Elias Haussmann and of Charles Lamb by Henry Meyer. At the entrance of the main Humanities Reading Room a bust by Carlo Marochetti celebrates the memory of the great Librarian of the old Round Reading Room, Sir Anthony Panizzi, while a bust of me by Celia Scott, donated by the American Trust for the British Library, is built into the east wall.

On the east wall hangs a large painted wood relief entitled *Penelope* by Joe Tilson celebrating the number of times that the word 'Yes' occurs in Molly Bloom's monologue in James Joyce's *Ulysses*. Next to it stands the bronze sculpture entitled *Sitting on History* by Bill Woodrow.

Most powerful of all, the bronze and glass tower housing the King's Library soars up in all its splendour of leather and vellum bindings from the basement below

← A second bust by Roubiliac of Sir Robert Cotton (1571–1631), whose manuscript collections donated to the Library included the *Lindisfarne Gospels*, graces the ante-room to the Manuscripts Reading Room, which is reached from the upper level of the Main Entrance Hall.

→ The belvedere tower on the third floor above the Main Entrance Hall, which looks south to the entrance doors, and west over the first-floor restaurant (pictured at left) and ground-level café (visible below).

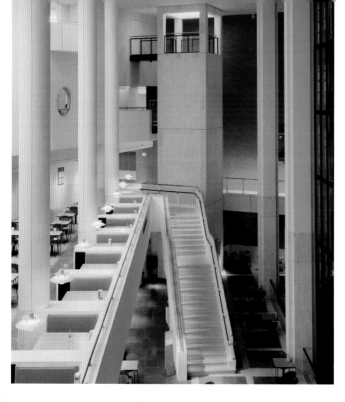

to rise six floors high as the symbolic centre of the whole building; its origin in the deep book basements below is emphasized by the use around its base of polished black marble, the reflections of which convey, by *trompe l'oeil*, the impression of the underworld receding into limitless depth.

General Amenity

There are a number of places dedicated specifically to the amenity of readers, the general public and the staff.

To enable parties of visitors to see into the large Humanities Reading Room without causing any disturbance to readers, the design included a route of access by lift from the Treasures Gallery to a viewing gallery at third-floor level; from this vantage point, a full view of the Humanities Reading Room can be enjoyed.

Within the concourse of the Main Entrance Hall, a self-service restaurant for both readers and general public is located to the north of the King's Library. There is also a café area at the level below, open to all. In both cases the predominant view is, very appropriately, towards the beautiful bindings on show in the glass tower of the King's Library.

← Alternative view of the belvedere tower, with the restaurant in the foreground.

→ Terrace outside the staff restaurant on the north side of the building.

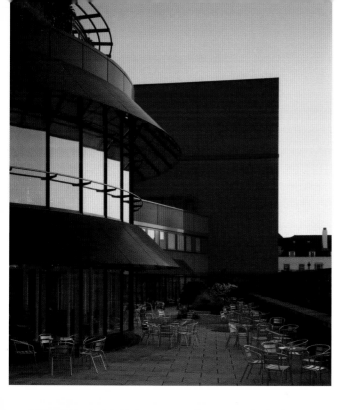

On the third floor, readers and Friends of the Library share separate areas of a common room. On the Main Entrance Hall side this has access to a 'belvedere' tower which looks south right back to the entrance doors; to the north, it has access to a roof-terrace with splendid views to Hampstead. The terrace is circular in form, enveloped by a metal and timber lattice to support climbing plants. This screen is punctured at seven points by low column bases which have yet to receive their intended sculptures. It is a high place of rest and contemplation, enclosed but open to the sky.

Finally there is a restaurant for staff overlooked by recreation and common rooms and opening out into a large terrace. This terrace is extended as a high-level acropolis affording access to the new Conservation Centre and Sound Archive.

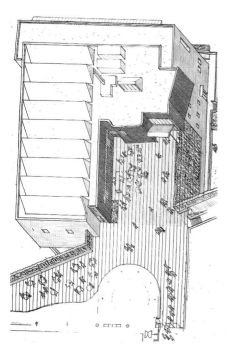

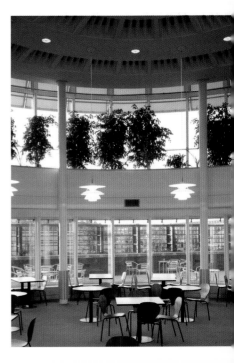

← Architect's drawing showing a bird's eye view of the new development on the north side of the Library, containing the Conservation Centre and extension to the upper terrace, due to open in March 2007.

→ Staff restaurant on the north side of the building.

The Reading Rooms

In the first place it should be understood that this is not a lending library but a research library; and secondly, that not all research is carried out in the same way. In the Library there are eleven reading areas which are broadly divided into the two patterns of use already alluded to.

Thus, in the closed-access Reading Rooms assigned to the Humanities Collections (which occupy the western range of the building), the space is almost entirely occupied by readers at their desks. Reference material lines the walls, but for the most part the books that are consulted are drawn from the storage basements. There is a wide range of Reading Rooms of this type, varying in size and each with its own quite specific character. The largest, Humanities, is three floors high with stepped terraces like a hanging-garden and in the top terrace is the Maps Reading Room. Next in size, the Rare Book Reading Room is overlooked by the Manuscripts Reading Room. In the Asian Reading Room a number of the magnificent paintings from the former India Office collection hang high on the wall over the open-access stacks.

Most of the readers in these rooms are committed

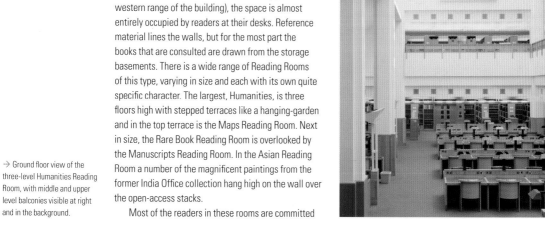

→ Ground floor view of the three-level Humanities Reading Room, with middle and upper level balconies visible at right and in the background.

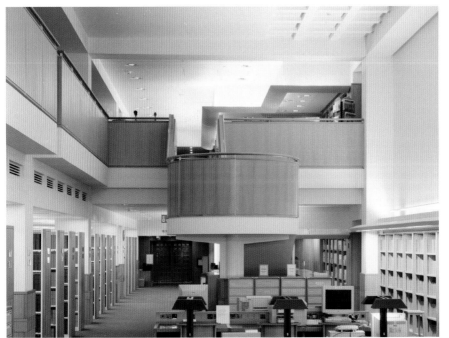

← The North Sciences Reading Room, looking south.

→ The Asian and African Studies Reading Room, with paintings from the former India Office collection on the wall at right. The architect's sketch shows the same view, before construction.

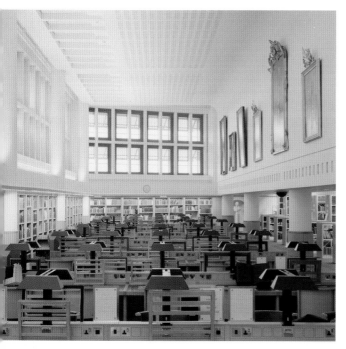

to an extended period of research, so the prime consideration has been to create a working ambience for sustained occupation and study. The outstanding characteristic of these rooms is that they are bathed in natural daylight, overcoming the threat of monotony. The light pours into the centre of the space by means of clerestory and lantern lights housed in the pitched roofs. Its properties of vividness and variation are a source of stimulation that no artificial lighting system can emulate.

Conversely, the Science Collections (and also the new Business and Intellectual Property Centre) are disposed on 'open-access' shelves which occupy the greater part of the floor space and to which readers are invited to help themselves. Since the centre of the space is fully occupied by the bookshelves, daylight is here introduced through windows from the side, illuminating reader positions which are accordingly located along both perimeters; the Midland Road frontage contains a three-floor-high reading area overlooked by balconies, which enables the readers to orient themselves in their searches throughout the stacks.

In all cases material may be summoned from the storage basements through the computerised catalogue, request and delivery systems.

Another major consideration was the difficult-to-define but ever-present 'body-language' of each reader. We all have a deeply personal level of sensitivity to our surroundings. Varying degrees of spatial enclosure or exposure induce varying feelings of comfort or discomfort in each of us. The old Round Reading Room of the British Museum offered one all-embracing spatial experience to the reader. It had its splendour, but it

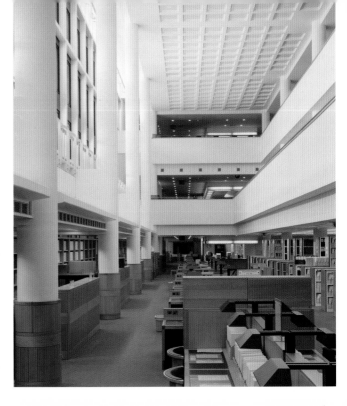

← South Sciences Reading Room, showing the triple-height reading area, viewed from ground level.

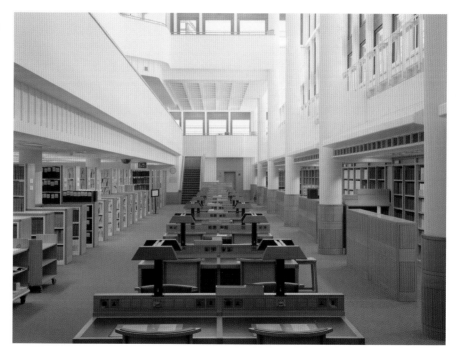

→ Reverse view of South Sciences Reading Room.

offered no choice of shelter to those who found the corresponding exposure relentless. However, in the new British Library the location and spatial disposition of the desks are intentionally very varied. For instance, in the General Humanities Reading Room, there is a significant difference between a reader's table at the balcony edge and one that is 'tucked in' below the terrace above, or one that lies in the tall perimeter vault, offering a generous choice to the reader. At the same time, all the seats open up a long-range view across the room as a stimulating contrast to the concentrated focus of close study upon page and monitor. There is thus a great variety in the choices available for location, form and disposition of workplace. As a further consequence of this design approach, each of the eleven Reading Rooms has an inherently different identity of its own.

Every individual has his or her own sense of what constitutes a comfortable personal space, and the wide range of choice offered in these Readings Rooms encourages each reader to find and take possession of his or her own place. This seems to be a major reason for the popularity of the Reading Rooms among the readers.

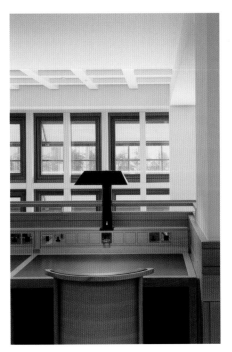

←↓ Each reader has a personal light, leather-topped desk, electric points, and leather and oak chairs.

→ The Treasures Gallery has on permanent display over 200 of the Library's most famous items including *Magna Carta* and the *Lindisfarne Gospels*. Daylight is excluded for reasons of conservation, and the items are lit by low-heat fibre-optic lenses.

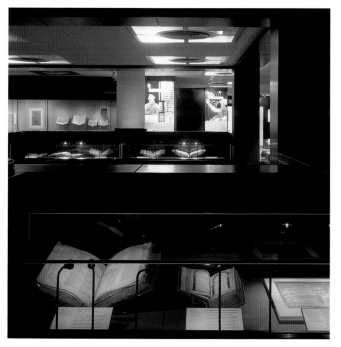

Exhibition Galleries

The range and quality of the Library's Collections of manuscripts, rare books, music and maps is unequalled in the world. It is the pride and joy of what the Library has to offer to the general public of all ages, nations and cultures, and its proper display is essential to the Library's life.

A shared foyer leading directly from the Entrance Hall gives access to three varied galleries which are open to all-comers. The Treasures Gallery displays precious works on paper that are vulnerable to too much light; therefore the general ambience is of a low-lit cavern in which the treasures are displayed in showcases lit from within by sparkling fibre-optic lenses. Here, in a rotating selection from the permanent collections, are presented examples of manuscripts (illuminated or plain), musical scores (from Bach to the Beatles), Nelson's last unfinished letter written to Emma on the morning of the Battle of Trafalgar, maps and globes, with set-piece displays for certain key documents such as *Magna Carta* and the *Lindisfarne Gospels*. Here also the visitor can enjoy 'Turning the Pages' of, among many other works, Leonardo's

notebooks, the original *Alice* books or the world's oldest printed book, the Chinese *Diamond Sutra* of 868 AD, in an active touch simulation invented by the Library. Re-entering the main concourse can be likened to emerging into daylight from the mouth of a cave.

The Pearson Gallery houses temporary exhibitions, drawing upon material on loan as well as the Library's collections. The exhibitions mounted here are created by the in-house team and are outstanding for their originality, inventiveness and expertise as well as for the subject matter itself.

A third gallery is used as a flexible public space. Its displays have covered the history of printing, book-binding and sound-recording techniques, and it is now used as an extension of the Pearson Gallery so that larger exhibitions can be mounted.

Conference Centre

The eastern flank of the courtyard is enclosed by a Conference Centre. This has its own entrance and therefore enjoys complete independence from the Library itself. The accommodation includes an auditorium to seat 250. Three seminar rooms range

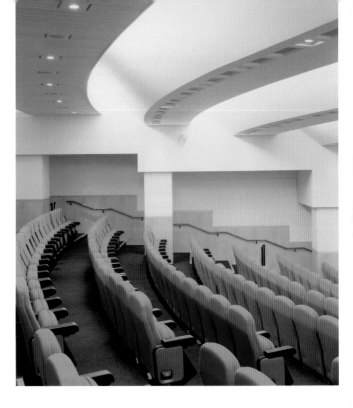

← ↑ The auditorium in the Conference Centre seats 250. It can be daylit or blacked out.

in capacity from 20 to 65 seats each, and there is a large foyer and bar. This space is very intensively used, for external conferences as well as for the Library's own programme of scholarly conferences or public lectures.

All of these rooms, including the main auditorium, can be daylit, although all have provision for blackout too. Here again, as in the Reading Rooms, daylight is seen to be both a stimulant to attention and a saving grace against moments of tedium.

The foyer to the bar contains a broad staircase with seating nooks to left and right as suitable places for drinking and discussion during intervals. The casual encounter is an essential extension to conference activities and by analogy with the 'Spanish Steps' in Rome, the architecture here seeks to create the appropriate relaxed ambience and sense of place to encourage such random contacts and freer discussion.

The staircase is graced by two donations: a large wood carving entitled *Spiral Sheaves* by David Nash; and a glowing tapestry by Patrick Caulfield entitled *Pause on the Landing* – a reference to an incident on the staircase in the artist's favourite book, *The Life and Opinions of Tristram Shandy*.

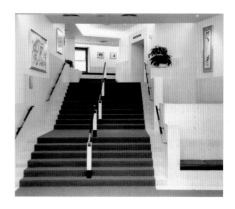

↑ → The 'Spanish Steps' leading down to the auditorium and the adjacent seating are designed to encourage relaxed discussion during intervals in conferences.

As we have seen, it had been the intention, right from the start, to include works of art in this way in the design of the building – not just to add them later as decoration, but to incorporate them into the architecture, embodying and elaborating upon the many themes addressed by a Library, and thereby helping to establish the special identity of the building. This entailed the selection of strategic locations for works of art distributed throughout the building. Many were already in the possession of the Library, but many new

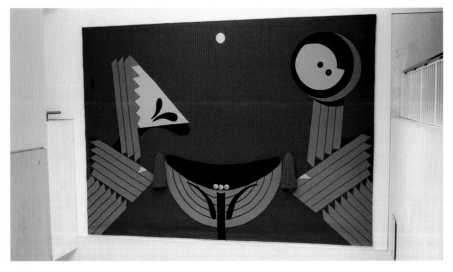

← Patrick Caulfield's *Pause on the Landing*, a tapestry that hangs on the landing between ground and first floors in the Conference Centre.

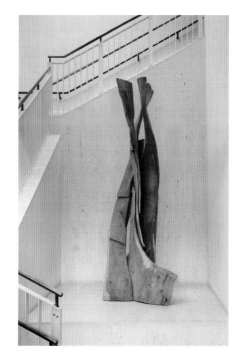

→ David Nash's wood carving
Spiral Sheaves, situated at the
foot of the stairs in the foyer of
the Conference Centre.

works have been commissioned or donated by generous
individuals and bodies in response to a detailed design
policy. The intention to 'integrate art and architecture'
has been much talked about but seldom practised
well. In the case of the British Library (in which already
works by ten major artists of the twentieth century have
been incorporated) that policy has been pursued in an
exemplary way.

Storage, Conservation and Distribution

The greater part of the 340 linear kilometres of shelving
for books, manuscripts, maps and other collections is
stored in three and a half floors below ground. This is
for two reasons.

The most stable environmental conditions, free from
variation in local or seasonal changes in weather, can be
secured below ground. It follows that this steady state
enables the maintenance of constant environmental
conditions with the minimum expenditure of energy
(temperature $17°c \pm 1°$; humidity $50° \pm 5°$).

Books are stored either in conventional fixed stacks
or in mobile shelving. There is a wide range of other
forms of shelf and cabinet types and dimensions to

receive maps, manuscripts and unique incunabula.

The uppermost level of the basement is dedicated to a continuous, horizontal layer system for the delivery and return of books. By this means the stored books can be delivered from all basements to any above-ground location. The system is generated from control despatch points in a number of discrete compartments. At each of these points, requests for items are received and the item itself is retrieved by hand. It is put into a plastic container tray, which will then be carried on horizontal conveyors and thence into paternoster elevators to the control room serving the point of request. Return to storage is achieved by reversing the procedure.

→ Diagram showing the Library's mechanical book-delivery system. Horizontal travellators serve vertical paternoster lifts to service counters in various locations, including the Reading Rooms, conservation laboratories, cataloguing offices. Note the proximity of the London Underground's Metropolitan, Circle and District Lines.

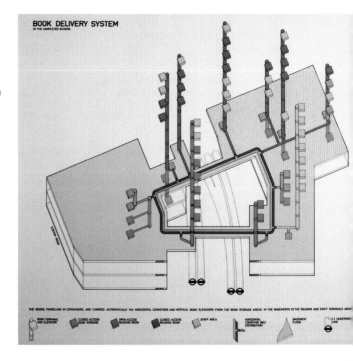

BOOK DELIVERY SYSTEM
IN THE COMPLETED SCHEME

THE BOOKS TRAVELLING IN CONTAINERS, ARE CARRIED AUTOMATICALLY VIA HORIZONTAL CONVEYORS AND VERTICAL BOOK ELEVATORS FROM THE BOOK STORAGE AREAS IN THE BASEMENTS TO THE READING AND STAFF TERMINALS ABOVE

BOOK TERMINAL AND ELEVATOR · CLOSED ACCESS BOOK STORAGE · OPEN ACCESS READING ROOM · CLOSED ACCESS READING ROOM · STAFF AREA · HORIZONTAL CONVEYOR BELT DISTRIBUTION · BASEMENT FLOOR · LT UNDERGROUND LINE

The Big Dig

In its ratio of above-ground to below-ground accommodation, the building has much in common with an iceberg: and since the sheer size of the basements required so much excavation, special measures had to be taken to minimise disturbance to major neighbours. In all, 50,000m³ of earth was removed. To this end the structural engineers, Ove Arup and Partners, devised the following strategy. First a diaphragm wall of interlocking steel and concrete piles was driven into the ground around the perimeter of the first stage of building. Next, foundation piles were sunk on a square grid (7.8m x 7.8m) to a depth of 30m. Steel columns were then lowered on to these pile-caps, each column bearing provision for connectors at every basement floor level. Then the topmost (i.e. piazza) floor slab was cast to form a stiff plate in connection with the columns in such a way that it also acted to stiffen the top rim of the diaphragm wall. The next move was to dig out the earth beneath the slab, like mining sufficiently deep to form shuttering and pour the concrete slab of the first basement. This procedure was repeated progressively for each of the five basement levels, building downwards, floor by floor. Of course since the columns were all firmly in place, it was possible to build the superstructure upwards from them at the same time: we were therefore building upwards and downwards simultaneously.

Postscript

'Those who would carry on great public schemes, must be proof against the most fatiguing delays, the most mortifying disappointments, the most shocking insults and worst of all, the presumptuous judgement of the ignorant upon their designs.' – Edmund Burke

The building took 36 years to complete its first phase of construction, and right up to the end its completion was, in Wellington's phrase, 'a damned close-run thing'. From the first, the project had many opponents in high places who favoured the continued location of the Library in the British Museum and who mounted a powerful campaign in the columns of the press to stick it out there, however inadequate the resources would have been. However, under the vigorous championship of the first two chairmen (Lord Eccles and Lord Dainton) the project

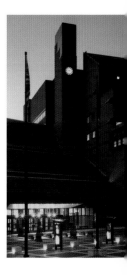

↑ The Library, viewed from the piazza at night.

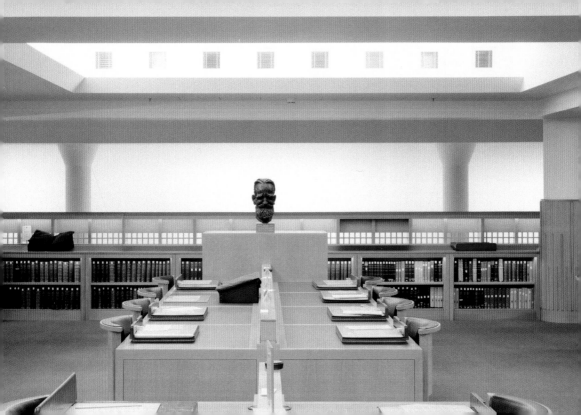

navigated between the Scylla of the self-appointed 'men of the future' who prophesied the death of the book, and the Charybdis of the architectural fogies who yearned for retreat into the world of Wren. As for those who came to use the building, we have a typical response in the words of one author and scholar, Margaret Drabble, who wrote on behalf of the visitors to the building of 'this much loved building':

> Many times I have felt the relief of struggling through the chaos of the underground station and the obstacles of the Euston Road to the calm and safety of the forecourt. But I had not consciously realised why it was such a relief. I had not fully noticed how carefully the hopeful but harassed reader is led from the street through the courtyard and through the lobby and upwards to the reader's desk, and to the publicly possessed privacy of the reading experience. I now know that even the switching-on of my reading light in Humanities 2, a small and almost secret act which I so enjoy,

was a moment carefully planned for me and me alone, or so it always seems to each and every one of us... This beautiful, warm, friendly and welcoming building manages to be at once a private place for each of us, and a great public and social institution – a place of silent study, and of meetings and greetings and assignations.

There are those of us who believe that the Library is the one last possession of Great Britain that can justify the claim to be truly 'great', and the underlying conviction of that fact has mercifully ensured its ongoing progress. A great library is like a coral reef whose exquisite structure as it grows proliferates a living network of connections; and its ramification is all of a piece, like knowledge itself – the knowledge that bridges the endless curiosity of the human mind, from the first pictogram to the latest microchip. It is of its essence that it grows: and, at the time of writing, with the new Conservation Centre and upper terrace under construction, it is indeed continuing to do so.

← Manuscripts Reading Room with bust of George Bernard Shaw, who donated royalties to the British Museum Library.

The British Library, designed by Colin St John Wilson and Partners, was formally opened by HM The Queen in June 1998.

This edition © Scala Publishers Ltd, 2007
Text © Colin St John Wilson, 2007

First published in 2007 by
Scala Publishers Ltd
Northburgh House
10 Northburgh Street
London EC1V 0AT
www.scalapublishers.com

ISBN-13: 978-1-85759-444-7
ISBN-10: 1-85759-444-4

Designed by Nigel Soper
Edited by Oliver Craske and Sarah Peacock
Printed in China
10 9 8 7 6 5 4 3 2 1

All images by Gerhard Stromberg except as follows:
Colin St John Wilson: 17 (left), 18 (right), 24, 31, 48 (left), 51 (right), 60
Stephen Bond: 43
Martin Charles: 42, 55
Oliver Craske: front cover, 11, 14, 30, 34, 35 (both), 36, 58
John Donat: 7, 23, 39
Michael Freeman: back cover
Chris Gascoigne/VIEW: 19
Getty Images: 12
Jason Hawkes: 17 (right)
Irene Rhoden: 27

Every effort has been made to acknowledge copyright of images where applicable. Any errors or omissions are unintentional and should be brought to the attention of the publishers.

An earlier version of the text was published as *The Design and Construction of the British Library* (British Library: London, 1998).

The publishers would like to thank David Way for his kind assistance with the book.

Front Cover: The British Library viewed from the piazza, with Paolozzi's sculpture *Newton* in the foreground.
Back cover: The Humanities Reading Room.
Page 1: Seating in the Entrance Hall. Like the walls, the flooring also serves to bring the piazza inside the Library, creating a transitional space.